this book
belongs to:

A book by Book on a Tree, Ltd
Text: Cosimo Lorenzo Pancini
Book design: Studio Kmzero
Lettering artwork: Giulia Ursenna Dorati,
Maria Chiara Fantini, Mattia di Marcantonio
Cover design: Andrea drBestia Cavallini
All images © Disney

Copyright © 2019 Disney Enterprises, Inc.

For information address Disney Editions,
1200 Grand Central Avenue, Glendale, California 91201.

ISBN: 978-1-368-04683-1

Printed in the United States of America
First Paperback Edition, November 2019
1 3 5 7 9 10 8 6 4 2
FAC-038091-19263
Visit www.disneybooks.com

Disney Art of Hand Lettering

An inspirational workbook
for creating beautiful
hand-lettered art about **LOVE**

Disney
EDITIONS
LOS ANGELES • NEW YORK

the WAY to get started is to QUIT talking and BEGIN doing

Introduction

There is something magical in the act of writing letters (and prose) by hand. Putting pen to paper, we create lines and curves that eventually arrange themselves into letters and then words. These days we have become used to sending and receiving messages digitally. But there are moments when some words are so important that they must not only be written by hand, but written by hand in a style that makes an even more impactful statement.

School notes, to-do lists, fridge memos? A quick scrawl will do. But a love letter? That demands something more. When we need to write down our deepest feelings, express special emotions, or emphasize a phrase that holds a special place in our hearts, it feels more natural to go back to pen and ink.

For centuries, deft writers have turned to calligraphy (from the Greek *kalligraphía*, which means "beautiful writing") when attempting to make a point or write something with a deeper message. The art of calligraphy gives people the chance to write with such elegance and style that the reader not only better understands the written message but also feels the passion and emotions of the writer.

Similar to calligraphy (and perhaps in tandem with it) is the art of lettering, which aims to illustrate beautiful-looking words by drawing them, rather than "only" writing them out; it's a very subtle distinction that you'll discover and gain a feel for on the following pages.

This book will guide you through many calligraphy and lettering styles. You will practice your skills by "writing" out beloved quotes you'll recognize from classic Disney films. You'll learn that different alphabets can express a range of emotions, and discover four distinct writing styles to express the theme of this book: *love*.

Beautiful hand lettering takes patience and practice, but, as the Fairy Godmother says to Cinderella:

How to use this Book

Our theme for this book is *love*. When Anna meets the trolls in *Frozen*, she is told that "Love's a force that's powerful and strange." Love is also a force that comes in many different forms. Sometimes it's sweet and dreamy; other times it's burning and fierce—forcing us to react in unpredictable ways: one at times may want to laugh and dance, or cry. Love is an open door, love is a song that never ends. . . . There are as many ways to describe love as there are ways to draw letters!

Once you have an understanding about the basic types of lettering and the tools you may find useful for expressing your feelings, this book focuses on four main sections (what we call *The Love Alphabets*). Each section is dedicated to a specific style of writing or lettering. Quotes are provided from famous Disney films that we feel best convey the mood of that lettering style.

For each style, you will be presented with an introductory guide on how to correctly write the letters and provided some practice pages. You will next have two pages with full quotes on them made available to you, and be given step-by-step instructions on how to execute and apply your newfound touch.

On the left is the original artwork, with a space for your version on the right!

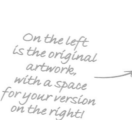

Before computers and digital typography, it was common to hand draw signage and custom graphics. Until the second half of the twentieth century, practically all writing, apart from that on printed paper, was original, created by one who had his or her own special custom or hand-painted lettering style.

Today we have a huge variety of font options (commonly known as digital typography) at our fingertips on our computers that allow us to choose a style for the message we're sending out. Some are serious, and others are more fanciful; some try to look hand-drawn (like Comic Sans), while others are more clearly cut, as if designed with a ruler and compass (such as Times New Roman). Despite their close ties, lettering, calligraphy, and digital typography are very different from one another, and it's important to understand why.

Typography
Lettering
Calligraphy

Calligraphy involves executing letters in a single, continuous movement of the hand, while it's holding a writing tool such as a brush or a pen. As letters are written by hand, there will always be small differences between two versions of the same letter.

Sometimes these variations will be intentional, as the aim of the calligrapher might be to attain a slightly imperfect look in a word. Before the advent of computers, the most widespread form of calligraphy was cursive script: a fast and elegant style of writing where every letter is connected to the other.

A good calligrapher knows the secret is not only the ability to write beautiful letters, but to do it quickly, linking letters with a continuous movement and making variations in them by simply changing the pressure on the writing instrument.

Lettering doesn't require letters to be written in a single movement. A lettering artist can sketch the outline of the letter, fill it with ink, then refine the shapes with a finer tool. While in calligraphy all letters usually sit on the same baseline, lettering gives you more freedom and flexibility with the positioning of letters. It's even possible to change the style from one word to another, juxtaposing cursive styles with capital letters.

FONT or *handwriting?*

If you want to distinguish a computer-generated font from hand-formed calligraphy or lettering, just look for variations in repeating letters. A calligrapher or lettering artist would never make double letters (for example "tt" in "letter") identical, especially in cases where they touch or overlap. In contrast, computer typefaces often produce clashes or unattractive pairings of letters where the same letter repeats itself (look for a double "t" or "g").

Although it seems playful and free from rules, good lettering takes its shapes and proportions from established calligraphy rules. For this reason, we will teach you to create lettering artwork by first presenting you a calligraphy style that you can understand and practice.

"Beauty" is written and inked in a single stroke: it's an example of calligraphy.

The letters of "Beast" are drawn and inked with many strokes. To mimic typography, we use lettering.

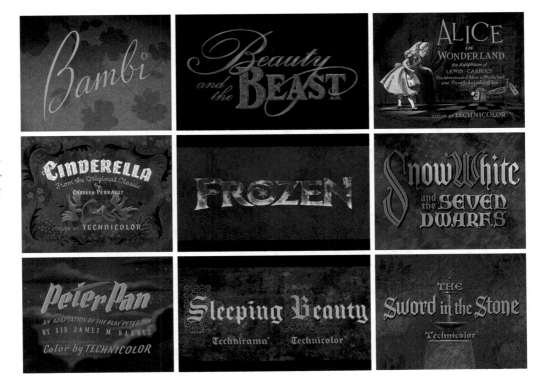

Here are some beautiful examples of the "title cards" that were hand-drawn in a pre-digital era by Disney graphic artists.

You can find here many of the inspirations for the lettering styles shown in this book.

As you start your journey through the world of drawn letters, you'll discover that we are surrounded by a great number of wonderful pieces of hand lettering styles on display in our communities: so, check out old shop signs, wall lettering, signs with ornately painted calligraphy, and handwritten menus. All of them can be inspiring; just look at the title cards above from classic Disney films to discover some incredible styles of beautiful handmade lettering!

Typography is the art of designing type and arranging it on the page. Although computers have made it very easy to control typography and produce beautiful results, no computer font will give you the same amount of personal expression that you can achieve when writing by hand. Computer fonts are precise and offer perfect repetition, while handmade lettering is a work of art, where every detail is influenced by your skills and emotions.

A lettering artist can be compared to a chef who is attempting to create a delicious recipe by mixing different typographical flavors. You should remember Gusteau's advice to Remy in *Ratatouille*: "You must be imaginative, strong-hearted. You must try things that may not work, and you must not let anyone define your limits because of where you come from. Your only limit is your soul."

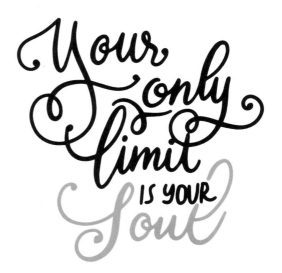

TOOLS *for the* *Lettering* ARTIST

You don't need great tools to create great lettering; even a humble pencil or a piece of white chalk can be used to create masterpieces. But some tools work better for some styles of writing, so you should try them all out and get a feel for which are the best for the style you want to work in. Practicing with different writing tools can be great fun, and even the most obscure ones are not expensive. As you start assembling your set of writing tools, remember Merlin's advice to Arthur in *The Sword in the Stone*: "It's up to you how far you'll go. If you don't try, you'll never know!"

Pencils

The pencil is the basic tool for sketching your word art and creating the guidelines for your letters. As a beginner, you're advised to use a hard lead pencil: No. 2 (or HB outside of the United States) to No. 4 (or 2H). These harder grades allow you to leave lighter marks on the page. A mechanical pencil is also an excellent choice, since it doesn't need to be sharpened and allows you to sketch with great precision.

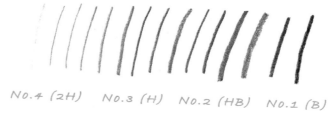

NO.4 (2H) NO.3 (H) NO.2 (HB) NO.1 (B)

Erasers

Plain thick block erasers will be your best friend as a beginner lettering artist. They're vital for correcting mistakes in your pencil sketches and for erasing pencil marks and guides once you've gone over them with ink.

Brush-pens create smooth, large lines.

Fine point eraser pencils are most useful when handling smaller details, while kneaded rubber erasers will help you remove marks you traced with ink without rubbing them away.

Paper

There's no need to start practicing with high-quality paper, as you'll need a lot of sheets to get the basic shapes right. Start with a ream of white computer paper to use alongside the pages of this book for practice. If you want to avoid drawing guidelines each time, you can use thin layout paper to trace over the pages of this book or a guide sheet you drew in advance. As you improve, you can switch to quality watercolor or drawing paper. Just remember that the best paper is thick, smooth, and not porous, allowing you to avoid ink bleeds and keep lines crisp.

Pen nib and holder

There are many types of penholders, from the inexpensive plastic ones to the fancy oblique holders that allow you to write at an exact angle. And there are *countless* nibs, each one with its own distinctive mark. Some calligraphy styles require a certain nib-shaped tool: flowing cursives require a flexible pointed nib, while Black Letter and Italic Scripts require broad nibs. Should you find pen nibs too difficult to use, think about turning to soft brush-tip pens to mimic the flowing line of the pointed nib, or a chisel-tip marker to reproduce the effect of the broad nibs.

Brush-pens

Though easier to transport and use than brushes, these pens are very difficult to control at first. But don't give up on them; they can create marks easily with great variation in width. Some brush-pens can also be refilled with watercolor inks, allowing you to quickly create lettering in many different colors.

Parallel pens

Available in various sizes, these pens are a great alternative to broad-nib calligraphy pens. If you're interested in Black Letter or Italic styles, these will be your first choice.

Water-based markers

These are a classic favorite for lettering artists and are available with all sorts of tips. Fine-tip pens (felt-tip markers or fineliners) are great for beginners, as they allow you to draw little details with great precision. Broader pens (chisel-tip or brush-tip) will allow you a greater variation in the width of your lines, meaning you can create interesting marks with great ease and speed.

Ink

To write with pen nibs, you have to dip them in ink, so you'll need some smooth and long-lasting black ink. Be sure to ask for calligraphy ink, which won't clog your nib when drying. You can also use color inks or liquid watercolor, but it's usually better to start with black, as it provides better contrast and can be more easily reproduced or scanned.

Pointed-nib pens create a variable line.

Broad-nib pens and parallel pens create an even line.

the BASICS OF Lettering

Now that you have all your writing tools, you are ready to start your first masterpiece. We know that when looking at a blank sheet, the task before you of creating some beautiful lettering can seem impossible! This is where you need to follow the advice of Walt Disney himself: "The way to get started is to quit talking and begin doing!"

THE WAY TO GET STARTED IS TO QUIT TALKING AND BEGIN DOING

the way to GET STARTED is to quit TALKING and begin DOING

1. Page layout

Lettering artwork starts with determining the best placement on the page for the various words. In this book, you will be presented with finished layout examples to copy. But don't feel limited by the ones we provide!

the WAY to get started is to QUIT talking and BEGIN doing

Experiment with swashes to fill empty spaces.

Make sure important words stand out by making them bigger!

Feel free to mix styles, but don't overdo it! It's usually best to limit yourself to two or three different lettering styles, or your artwork could resemble a messy bedroom!

THE WAY TO get started is to QUIT TALKING AND BEGIN DOING

Use diagonal guidelines to make slanted letters.

Catch the reader's attention with unusual shapes for important words!

Start your lettering work by studying the phrase you want to letter, writing it down in pencil on paper numerous times in various ways (uppercase, lowercase, or cursive) to understand its flow and rhythm. Some words are more important and need to be drawn bigger or emphasized in some way, while others deserve less attention and can be drawn smaller.

To better position the phrase in the available space, you will probably insert some line breaks,

as this will allow the final piece to neatly fill the space on the page, rather than be on a single long line. Be extremely careful to do this in a meaningful way, making each line of the phrase complete and purposeful.

As you begin to sketch your composition, try to arrange the words in different ways. Lettering artists do this using many small, quick thumbnail sketches so they can check the effect of different sizes and emphases placed on each word.

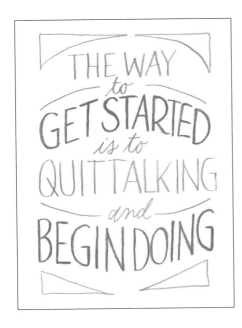
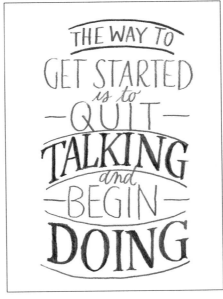
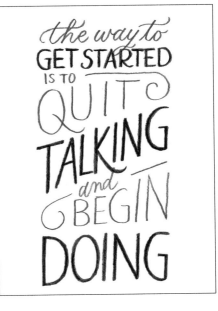

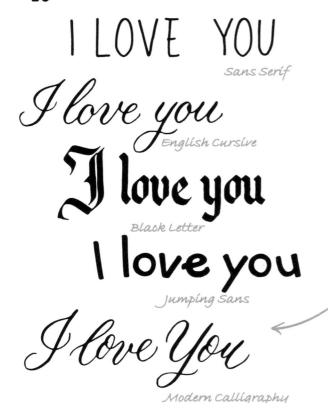

I LOVE YOU
Sans Serif

I love you
English Cursive

I love you
Black Letter

I love you
Jumping Sans

I love You
Modern Calligraphy

ABCDE
Block letters

2. Choose the right letter style

The magic of lettering lies in the contrast between the shape of the letters and their meaning. There are infinite ways that you can write the same word, by stretching, stylizing, and transforming the letter shapes. But these changes in form will also influence the meaning of the word: even the tiniest tweaks can evoke a completely different emotional tone.

Look at the examples to the left: each style of writing is a bit like an actor speaking the same line of text in a different tone of voice: some are more passionate, some more serious, some colder in tone . . .

Although there are endless variations, we can divide the main lettering styles into five families:

Block letters (also known as printscript or print writing) is often the first style of writing we learn in school: letters are written in uppercase and separate; shapes are usually derived from simple straight lines.

ABCDEFGHIJKLMNOPQRSTUVWXYZ

Try tracing this simple block letter alphabet in the space below:

ABCDEFGHIJKLMNOPQRSTUVWXYZ

. . .then draw it using the guidelines to keep your height consistent:

ABCDEFGHIJKLMNOPQRSTUVWXYZ

Here we add small lines to the main strokes of the letters. Draw this serif alphabet using the guidelines:

Serif letters are those that you usually see in printed books, where small lines (called "serifs") are added to the top and the bottom of the main strokes of a letter. Letters with serifs are more readable than letters without them; they're often used to print and display long texts. Serif letters are the more ancient shapes of Latin writing, derived from old Roman stone inscriptions.

Scripts are lettering styles that derive from cursive calligraphy, with fluid strokes usually connecting all letters. To have more attractive scripts, it's usually better to use a flexible writing tool, like a brush marker or a pointed nib, to create the flowing and variable lines that make scripts legible and pleasing to the eye.

ABCDE

Serif letters

abcdefg

Script or cursive letters

abcdefghijklmnopqrstuvwxyz

Try tracing the loopy cursive alphabet in the space below:

abcdefghijklmnopqrstuvwxyz

...then draw it using the guidelines:

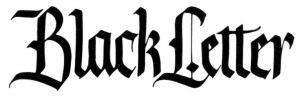

Gothic Letters

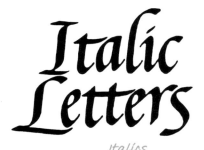

Italics

Black Letter (also called Gothic) are beautiful lettering styles from the Middle Ages. Their angled marks, created with a broad nib, may feel difficult to read but are very elegant for their vertical rhythm.

Italics are calligraphy styles developed in Italy in the fourteenth century. The letters are slightly slanted to the right and are sometimes connected. This style was translated by typographers into printing, and Italics are still used today to put emphasis on some words.

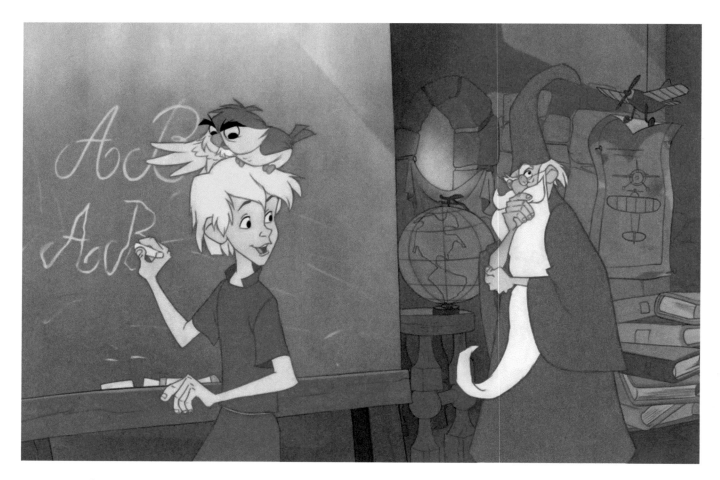

This scene from The Sword in the Stone (1963) shows what happens if you try to write letters without knowing their shapes. Poor Arthur must practice a bit more before mastering his English Cursive!

3. Pencil your artwork

When you are satisfied with your thumbnail sketches, you can begin your artwork by creating some pencil guidelines. You will usually need three guidelines for each line of text:

Caps line: this is the height of the taller letters.

Waistline: this is the height of lowercase letters, also called the "body" or the "x-height."

Baseline: this is the line upon which most letters "sit" and below which descenders extend.

With your guidelines in place, start to very lightly draw the "skeletons" of each letter. Try using a mechanical pencil to help ensure precision. Take care to keep the proportions and spaces between letters consistent.

Once the placement of the letters is correct (and you are confident of your proportions), you may start adding more details like serifs, decorations, and flourishes, and lightly add "body" to your letters by making the descending lines wider.

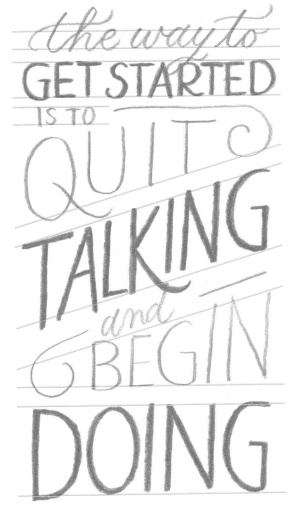

HOLDING THE PEN

Holding the pen correctly is the secret to writing with fluidity and avoiding writer's cramp. Always hold the pen lightly, resting your palm on the table, and try to use your whole arm to write, while keeping your wrist and fingers as still as possible.

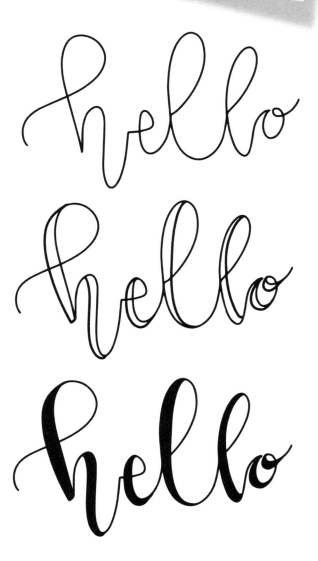

4. Ink your artwork

When you have a clean, light pencil guide, you can finalize your artwork by inking it. As previously noted, there are two ways you can ink letters: in a few continuous strokes, varying the width of the line using the nib or brush shape and pressure of the hand (calligraphy), or by first drawing each letter's outline and then filling it with ink (lettering).

Many lettering artists actually mix the two inking methods to balance speed and ease of execution.

Calligraphic inking is more difficult for beginners, as all letters must be written with few controlled strokes. However, as all the beautiful shapes we see in letters today derive from the tools that were once used to write them, knowing calligraphy is mandatory for every lettering artist. Therefore, in this book all the alphabets will be presented to you with calligraphic instructions, specifying the best tools necessary to execute them, and the correct way to write them with simple, well-executed strokes.

Lettering inking involves drawing each letter with many strokes, often changing your tool, using fine tips to draw outlines and fine details, and bigger brushes or markers to fill wide spaces. If you feel more confident with this sort of inking, you can produce beautiful artworks, even if you're not a great calligrapher! Simply try to reproduce the flow of the ink from the calligraphy instruments, learning where letters become wider or thinner due to the hand movements and the tool positions.

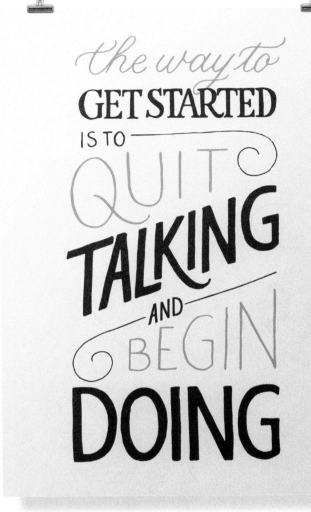

5. Finalize

When you are finished with your lettering, lightly remove any trace of the pencil sketch with a clean eraser. Frame your artwork, or better yet, give it as a gift to a friend or loved one. And if you're unsatisfied with the result, don't be afraid to start again: practice makes perfect, and repetition is key.

Keep practicing and you'll soon discover that you're actually doing something that just a few pages ago seemed impossible . . . because, as Walt Disney once said, "It's kind of fun to do the impossible."

it's kind of fun to DO the impossible

WALT DISNEY

1. English Cursive

Our first style is a very traditional cursive calligraphy, full of timeless elegance: the English Cursive. It's the sort of elegant handwriting that you'd expect a princess to use, and it's not by chance that it appears in the 1991 title card for *Beauty and the Beast*, where it represents the charming Belle. It's the perfect style to use for our collection of quotes about *romantic love*!

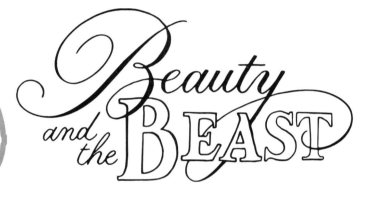

2. Gothic Script

Not all stories of love are about dreaming of romantic encounters. Sometimes true love is a force that makes us face our fears and give our best. For some memorable quotes about this *epic love*, we will use an age-old writing style that makes our words fierce and strong: the Gothic Script.

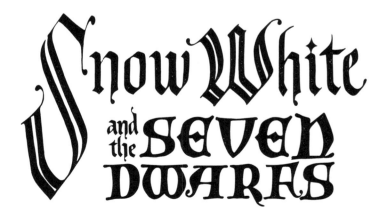

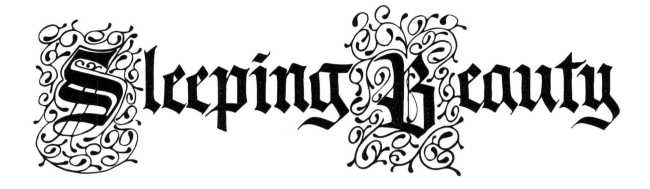

Ever since it flourished in the Middle Ages, it's common to see Gothic Script used in fairy tales set in that period to give the text a flavor of a timeworn fable. You can spot Black Letter (a type of Gothic Script), for example, in the title cards for *Sleeping Beauty* (1959) and *Snow White and the Seven Dwarfs* (1937).

3. Jumping Sans

Having learned that it's possible to make words communicate emotion by appearing soft and romantic or hard and strong, it's worth trying to alter styles and mix moods. Sometimes you might want to express love in a sweet, joyous way without being too romantic and formal. For our section of quotes about *sweet love*, we are teaching you a new style called Jumping Sans that's inspired by the lettering of the Winnie the Pooh logo:

4. Modern Calligraphy

Many of the lettering pages from the first three sections feature drawings of Disney characters next to the lettering artwork, but in the final section we will teach you how to use your newly acquired lettering skills to produce *Calligrams*, compositions of letters that create shapes and drawings.

You will learn to form Calligrams by simply writing a looser English Cursive style called *Modern Calligraphy*, which is perfect for hand lettering the free-spirited quotes collected in the *Fearless Love* section. And naturally, it appeared in a classic Disney title card: the one from the 1942 film *Bambi*.

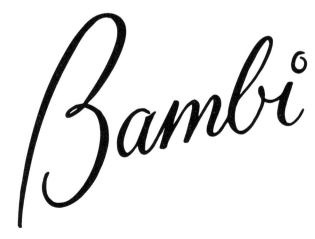

English Cursive

This elegant script evolved during the first half of the eighteenth century in England, and from there it spread all over the world. It was often called "Copperplate" because it was commonly used for copper engraving. In early usage, English Cursive was written with quill pens, but from the beginning of the nineteenth century these were replaced by more flexible, resistant, and economic pen nibs.

Difficulty: medium.

Tools and techniques: to obtain the characteristically thin lines of the English Cursive style, you should use a flexible pointed pen nib, or a fine-tip brush marker. Start practicing with long, steady strokes, varying your hand pressure to obtain thicker or thinner lines.

STEP 1 — Practice making even, diagonal downstrokes.

STEP 2 — Now try forming basic shapes, resembling hooks. Downward lines should be thicker, while for upward lines you should slowly decrease the pressure to make the curves thinner.

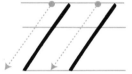

STEP 3 — Attempt connecting a series of "l" and "i" shapes, practicing smooth links between the letters.

STEP 4 — Try your hand at writing loopy letters. Always trace the form counterclockwise and begin at the top of each letter.

Tip: the secret to attaining an elegant English Cursive style is in the lightness and thinness of the lines you are drawing out for your letters. As your hand moves upward, decrease pressure to a minimum to get a thin stroke. As your hand moves down, increase pressure to make the line thicker. If you use a marker or a brush-pen, you will have thick and playful strokes. For an even and more elegant style, try a pen nib, which allows for maximum precision.

Tilting your sheet of paper can help you!

a b c d e f g h i

j k l m n o p q r

s t u v w x y z

Use these pages to learn how to write lowercase letters.

a a a a

b b b b

c c c

d d d d

e e e e

f f f f

g g g g

h h h h

i i i

j j j j

k k k k

l l l l

m m m t t t

n n n u u u

o o o v v v

p p p w w w

q q q x x x

r r r y y y

s s s z z z

Now let's practice capital letters!

A B C D E

F G H I J

K L M N O

P Q R S T

U V W X

Y Z

Romantic

Ariel

Romantic

Ariel

P R B

Tip: be sure to have mastered lowercase letters before trying majuscules! Their shapes are more complex and require more practice. Don't be disappointed by the early results, and keep refining the shapes by making the lines as smooth as possible. Also, practice similar letters in groups: you'll soon learn that when you can master a "P", then letters like "R" and "B" will be much easier to write.

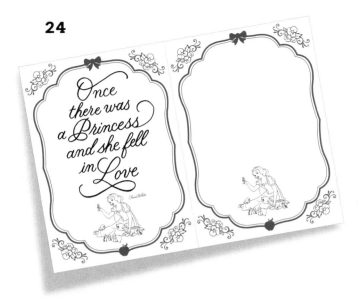

You're now ready to start creating your Disney lettering artworks based on English Cursive script! Over the next few page spreads, you will find blank templates (on the right page) where you can copy the quote you see on the left page.

We will guide you step-by-step in the first two artworks, so you can initially try tracing over guidelines and letter outlines. Let's start with the perfect quote to begin with, taken from the 1937 classic *Snow White and the Seven Dwarfs*:

STEP 1 — Using a soft brush-pen, practice forming the letters by tracing the words on this page. You'll see additional swirls on the uppercase letters: try to get them right with a single, smooth movement.

STEP 2 — When you feel confident about forming the individual words, it's time to practice them in the composition. Usually, you would trace pencil guidelines and then draw the skeleton of your letters, but for this first project we have provided you with the letter outlines for you to trace using your pointed pen nib or fine brush-pen.

STEP 3 — You are now ready to create your final piece! Use the blank template on the right page of the following spread to create your original artwork, using the left page for reference. And if you're not completely satisfied with it . . . remember that practice makes perfect!

Once
there was
a Princess
and she fell
in Love

SnowWhite

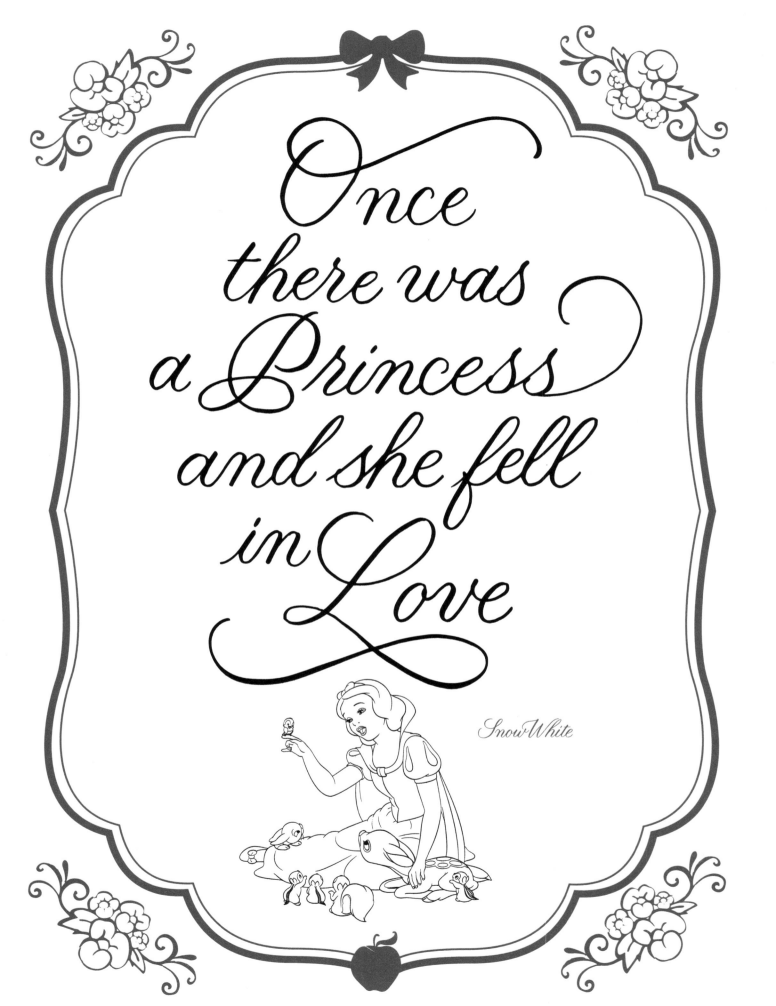

Once there was a Princess and she fell in Love

Snow White

28

This new artwork will allow you to play with varied letter sizes using the same alphabet. Keep in mind that when you're creating a lettering piece, you have to pick out the most important words in your phrase and put them center stage on the page, making them bigger or more elaborate to get the attention they deserve.

In this artwork, featuring a quote from *Beauty and the Beast*, we want to make the first word as beautiful as possible—not only to explain its meaning . . . but also because it refers to our heroine! So, we will add an elaborate flourish to the first letter and switch to a smaller, lighter pen for other less significant words.

STEP 1 — Just as you did for the previous lettering artwork, write all the words in the same size, using the guidelines. At first, just focus on the single letterforms.

STEP 2 — On the next page, you'll find guidelines of different heights, thus emphasizing the word "Beauty" over the others. Use them to lightly sketch the structure of your letters in pencil; then use a medium-sized brush-pen to ink the bigger words and a fine-tip brush-pen to ink the smaller ones.

STEP 3 — Having inked the letters, you can go ahead and add flourishes. When drawing them, try to keep an eye on the overall composition in order to keep it balanced.

Tip: the calligraphic flourish is one of the most fun elements to master, but it is necessary to practice creating balanced forms first. To start with, try out different ways to write an "s", adding curls (and trying to make them symmetrical). By intertwining many "s" shapes horizontally, you can add elegant flourishes to your calligraphy!

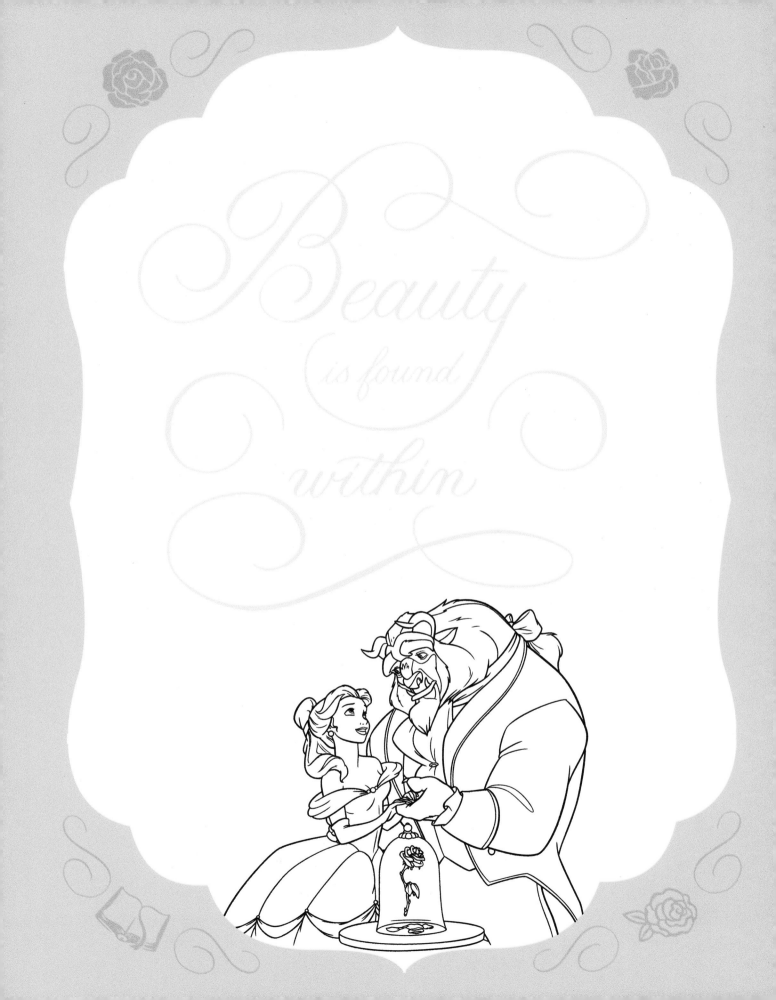

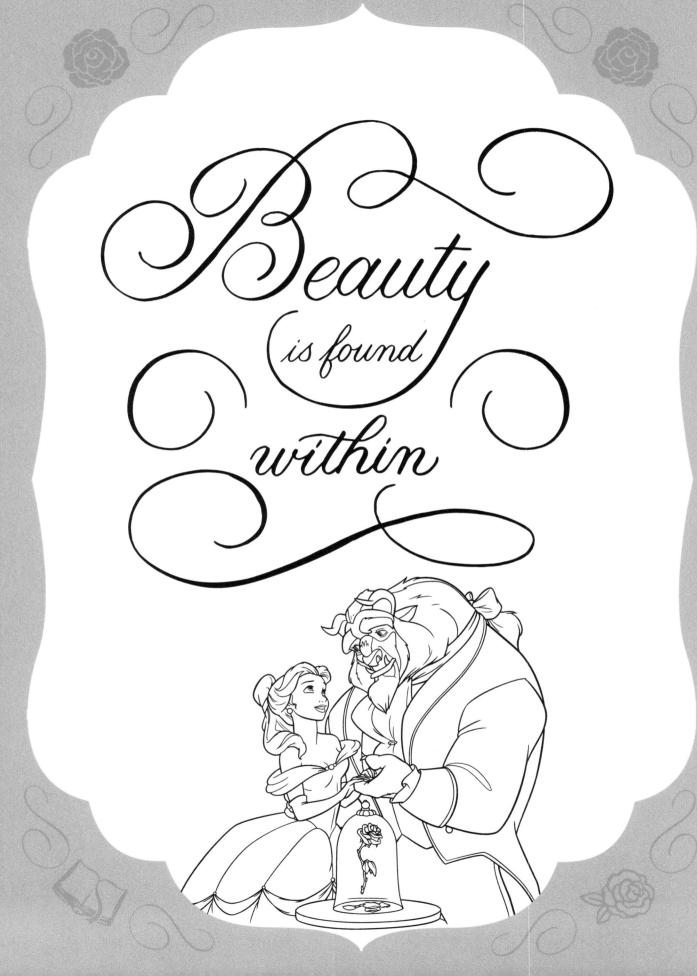

he loves me...

HE LOVES ME NOT...

He loves me!

Ariel

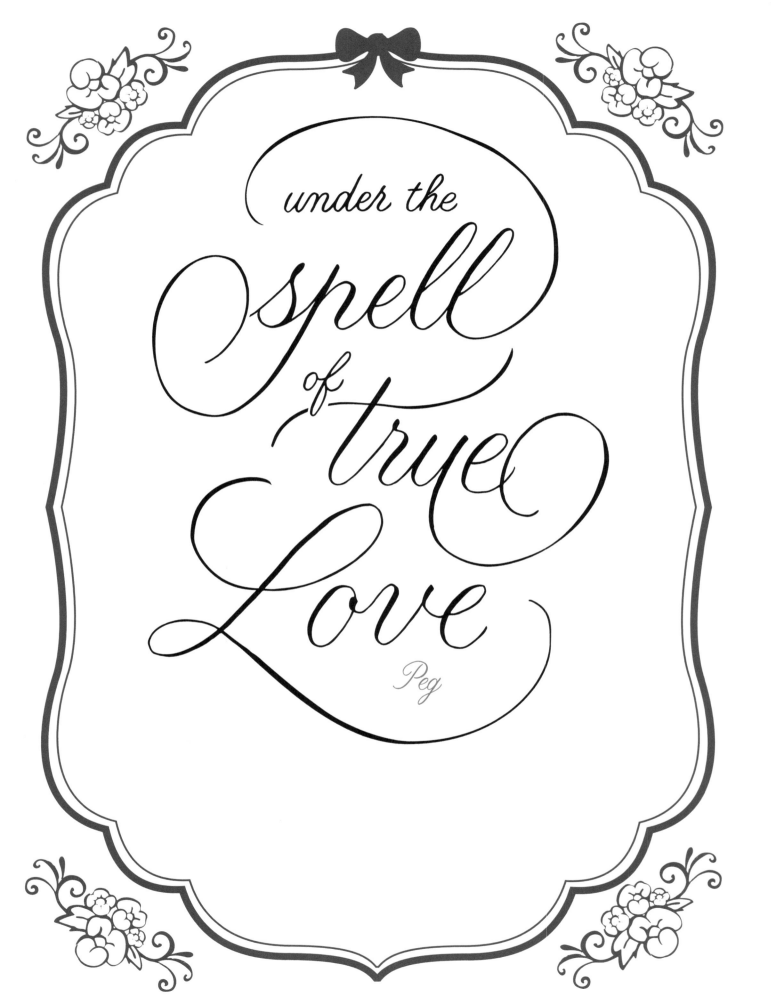

under the

spell

of true

Love

Peg

YOU'RE

the One

I'VE BEEN

looking

FOR

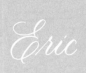

Eric

Good night
my handsome
Prince

Jasmine

Black Letter

This alphabet is a simplification of one of the most ancient forms of writing, called Gothic Script or Textura, which originated in northern Europe around the year AD 1000.

Gothic was a typical script in the Middle Ages: narrow and sharp, elegant but sometimes not easy to read. The contrast between the thick and thin strokes was traditionally quite stark, giving the effect, from a distance, of a series of thick black marks rather than letters. For this reason the Gothic Script was also commonly called "Black Letter."

Difficulty: medium.

Tools and techniques: to obtain a typical Gothic lettering style, you need a pen nib with a blunt edge or chisel-tip markers. If you keep the tip at forty-five degrees, you will attain even, vertical strokes and variable width diagonal strokes.

STEP 1 — Start practicing with a simple letter like "i". Keep the tip of your pen or marker inclined at 45 degrees.

STEP 2 — Keeping the same pen angle, add a thin upstroke to the second shape to write the letters "m" and "h".

STEP 3 — It's time to practice more rounded strokes. Start with the letters "o" and "a".

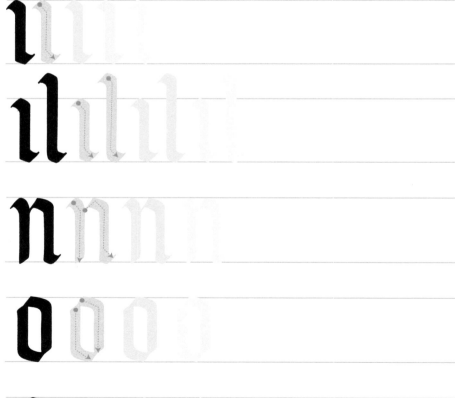

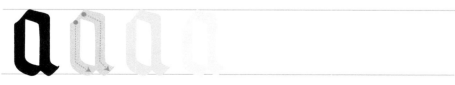

STEP 4 — You can use this kind of curve for many letters, like "c" and "e".

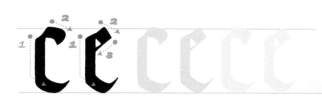

STEP 5 — Now practice by writing the whole alphabet. Always start with simpler letters and repeat until you feel confident with all of them.

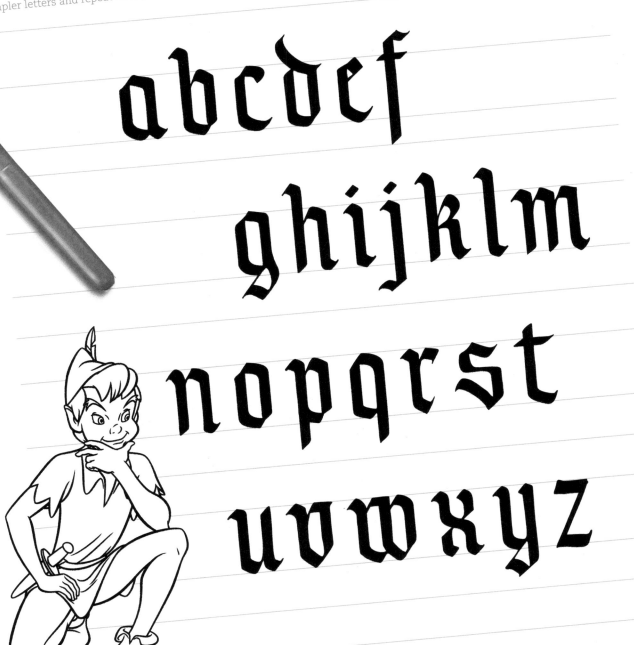

abcdef
ghijklm
nopqrst
uvwxyz

a a a g g g

b b b h h h

c c c i i

d d d j j

e e e k k k

f f f l l l

m t

n u

o v

p w

q x

r y

s z

ABCDEF

GHIJKL

MNOPQ

RSTUV

WXYZ

Robin Marian

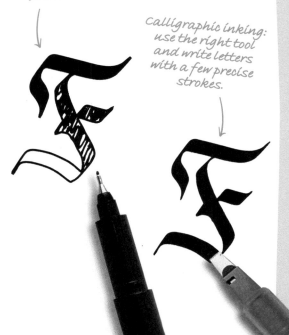

Lettering inking: draw the outlines, then fill in the letters.

Calligraphic inking: use the right tool and write letters with a few precise strokes.

Tip: Black Letter capital letters are beautiful, but far more detailed and difficult to write than the lowercase letters in the same typeface. If you find them too hard to write with calligraphy, you can try to learn to draw them using lettering techniques.

To do this, just draw the letters with a pencil and then ink the outlines with a fine-tip marker. Before filling the letters in with black, you can still add details and correct any mistakes in the letter shapes.

It's up to you to choose between calligraphy or lettering while creating your written artworks. The former is faster but needs more control; the latter gives you more chances to correct mistakes and add details. There's no right way to do it, and as Mary Poppins would say: "Open different doors. You may find a you there that you never knew was yours."

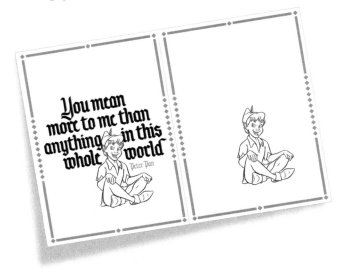

Now that you've practiced the geometric Gothic letter shapes, you are ready to start a new Disney lettering style featuring Black Letter.

Once again, we provide two warm-up pieces with detailed instructions, a step-by-step guide and guidelines, and outlines to trace over.

Our first Black Letter artwork features Peter Pan expressing one of the most epic love quotes ever! It's not a short phrase, so it will help test your skill at keeping the right space between the letters, creating the wonderful texture that makes Gothic Script unique.

STEP 1 — As usual with Black Letter, the first step is to choose a writing instrument of the right size and shape! This first artwork has letters that are exactly the same size as the ones you've been practicing with on the previous pages, so keep using the same chisel-tip marker or pen nib you've been using up until now. Once again, if you want you can use a lettering technique instead of a calligraphic one, and trace the outlines with a fine-tip pen, filling the inside of each letter. Choose the technique that feels more right to you!

STEP 2 — Trace the phrase on this page, trying to keep a steady hand and rhythm. You'll notice that some letters (like the lowercase "d") can have slightly different shapes: this is something that calligraphers do to make the letters fill the space more evenly and to add more flair to some words.

STEP 3 — You can now use the guidelines on the following page to write without tracing. Try to make some of the letters go behind Peter: this will make your lettering more three-dimensional and interesting!

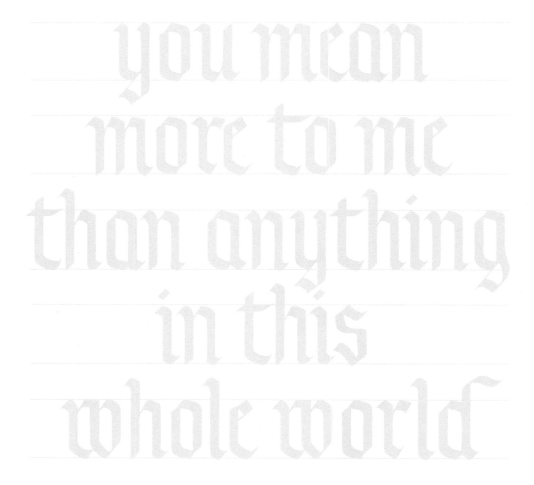

You mean more to me than anything in this whole world

Peter Pan

You mean more to me than anything in this whole world

Peter Pan

54

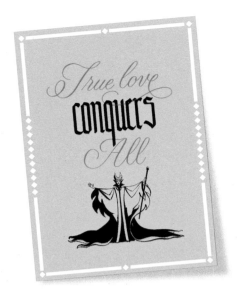

This artwork will show you how you can mix two different alphabets to express different moods. We will use English Cursive to create an interesting contrast to the dark shapes of Black Letter.

We will also show you how you can easily change the proportions of Gothic letters by keeping the width the same while making the vertical stems longer. Your words will become far more epic and impressive—the right tone of voice for our next quote as spoken by Maleficent from the 1959 classic *Sleeping Beauty*!

STEP 1 — Once again, start by tracing the basic shapes on this page. You'll have to change your writing tools to switch from the swirling shapes of English Cursive to the strong lines of Black Letter. Also, practice changing the vertical size of your Black Letter shapes until you are satisfied with the result.

STEP 2 — When you have a complex interplay between different alphabets, be sure to lay down guidelines to position your words, and maybe lightly pencil the letter shapes so that you can follow them while inking. We've made everything easy for you with the light guidelines on the following page!

STEP 3 — Now it's time to make it work in the final composition! To make the artwork more interesting, you can use different ink colors: red for the script letters and, naturally, black for Black Letter. If you're using calligraphy techniques, don't worry about the letters overlapping. But if you're drawing each letter, you can also create an interesting interplay between the different words, making cursive lines flow around the Black Letter stems.

True love
CONQUERS
All

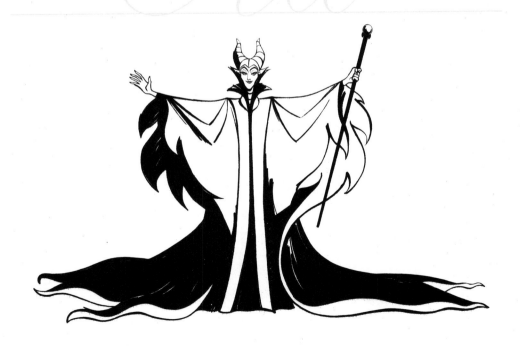

True love conquers All

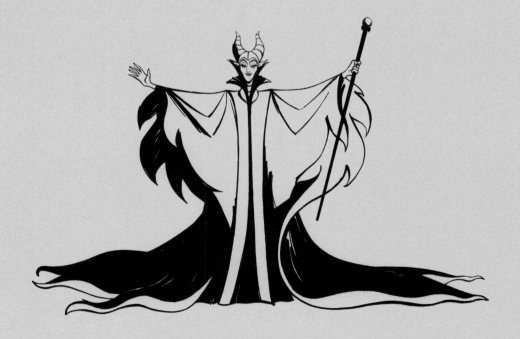

Faint hearts never won fair lady

Robin Hood

I'd rather
die tomorrow
than live
a hundred years
without
knowing
you

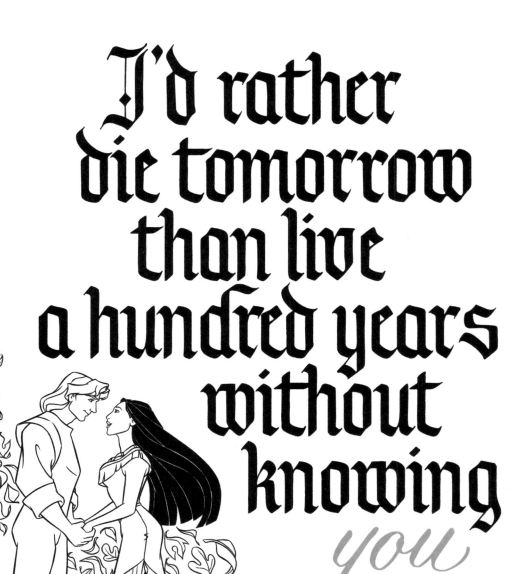

John Smith

You deserve to have your wish come True

the Blue Fairy

Only an act of true Love can thaw a frozen Heart

Grand Pabbie

Some people are worth worth Melting for

Olaf

You risked your life to help people you Love

Mushu

Jumping Sans

Not all writing styles are as old as the ones we've introduced you to so far: in fact, many computer fonts that we use every day were created no more than thirty years ago! Today, anybody can develop a new writing style—and come up with new ways of drawing old trusted alphabetical characters.

To show you what we mean, we're teaching you a completely new alphabet, inspired by the shapes of a Winnie the Pooh logo. After guiding you through the delicate shapes of English Cursive and the precise width of Black Letter, here comes an easier alphabet to add to your lettering skills. Let's learn "Jumping Sans"!

Difficulty: easy.

Tools and techniques:
This is probably the easiest of our alphabets to master, and also the one requiring the simplest tools. Use any medium-sized marker that allows you to draw the letter with a single smooth movement, without having to go over the lines more than once.

STEP 1 — Start by making two pairs of guidelines and initially write in normal block letter, trying to keep the letters the same height.

STEP 2 — Now try to rotate each letter a little bit: clockwise for the even letters and counterclockwise for the odd ones.

STEP 3 — As soon as you get the bouncing rhythm right, you can also move the letters vertically, alternating between each pair of guidelines.

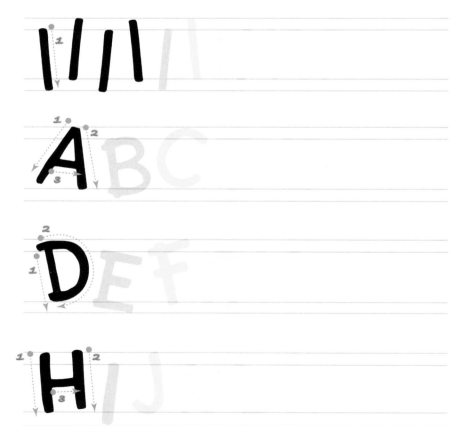

Jumping Sans was born thanks to an old Winnie the Pooh logo which, through its bouncy rhythm, seemed to perfectly evoke the happy bouncing of a walk through the forest . . . and is just right for a collection of sweet quotes about love!

The way the simple Sans Serif letters in this logo are jumping up and down along the baseline makes this lettering belong to the so-called "bounce lettering style," one of the "Modern Calligraphy" styles that you can discover on the internet.

From computer screens to book covers, or from street posters to supermarket labels, you should always be on the lookout for lettering styles that inspire you!

STEP 4 — For the uppercase alphabet of Jumping Sans, we used very basic Sans Serif letter shapes. But some details, like the arms of an "E", "F", and "D" that extend past the stem of the letter, make it slightly similar to a serif typeface.

A B C D E
F G H I J K
L M N O P
Q R S T U
V W X Y Z

a b c d e
f g h i j k
l m n o p
q r s t u
v w x y z

STEP 5 — Lowercase letters in Jumping Sans have simple shapes based on round circles and straight lines. The challenge here is not to make them perfect, but rather to keep the rhythm pleasant and bouncy. As you practice them, once again, be careful to notice the little details (like the lines of the "e", "p", and "h" that cross the stems, resulting in a little "twiglike" effect).

Sometimes it only takes tiny details to make a big difference. . . . And if you don't believe us, remember proud Mushu when he says:

I'm not tiny... I'm travel sized!

mushu

The secret of a beautiful lettering piece is creating imbalance, tension, and movement between the letters.

Remember to make each word best express its meaning through its drawing style. You can make words that seem happy or sad, strong or weak, or motionless or even appear as if they're dancing. Make each word fit in its own space and interact with the words around it. Let the letters dance!

Let the letters dance!

a a

f f

b b

g g

c c

h h

d d

i i

e e

j j

Use these pages to learn how to write lowercase letters.

k k

l l

m m

n n

o o

p p

q q

r r

s s

t t

u u

v v

w w

x x

y y

z z

PLAYING WITH GUIDELINES

A good way to create interesting lettering compositions is to change the shape and inclination of the baseline. In Jumping Sans, for example, we made the letters flow up and down, as if they were standing on a wave:

waves

But there are many more options you can try! For example, you can curve the baseline, as if the text was written on an archway:

curve

Or you can draw your guidelines at an angle, keeping the axis of the letters vertical, so that they will appear slanted. You have probably seen this in some old signs, where smaller and what are deemed to be less important words are written in this way to take up less space:

Parker and sons

Lastly, you can combine all of the above together, creating a composition where each word uses the shape that best expresses its meaning. Each word is a bit like a character in a story, Walt Disney used to say:

I try to BUILD a full PERSONALITY for each of our cartoon CHARACTERS

— WALT DISNEY —

When you have mastered these variations on the basic letter shapes we used in Jumping Sans, you can also try them out with the typefaces we previously studied. A slanted baseline will work very well with Black Letter, while using a wavy baseline with English Cursive will result in a more relaxed script style, called "Modern Calligraphy," which we will practice in the next chapter.

After practicing both uppercase and lowercase letters—and learning some tricks about moving the words on the page—it's time to try our Jumping Sans alphabet in a lettering composition.

For this quote by Piglet from Winnie the Pooh, we will use English Cursive for some words, applying the bouncy rhythm of Jumping Sans to the style. Once again, we will use different sizes to underline important words and make our composition more interesting.

STEP 1 — Start by tracing the words using the outlines provided on this page. Familiarize yourself with the letter shapes and learn how to rotate them slightly and move them vertically, in order to create the distinctive bouncy look. Try to apply the same bouncy style to English Cursive while keeping the letters connected in a fluid manner.

STEP 2 — Use this page and the next to practice inking the composition. Use a medium-sized marker for Jumping Sans and a brush marker for the English Cursive words.

STEP 3 — When you're ready, turn to page 79. Lightly trace some guidelines and write out the phrase. Use a pencil so that you can easily erase and correct the layout if you need to. When you're happy with your composition, ink your masterpiece!

It is so
much more
friendly

with

two

Piglet

It is so
much more
friendly

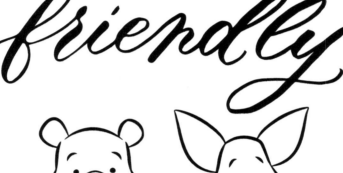

with

two

Piglet

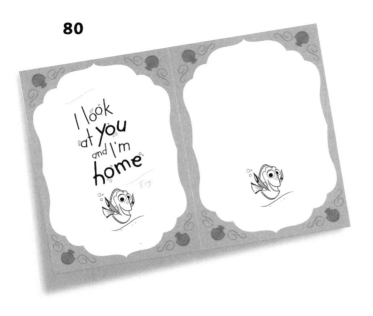

It's time to practice our slanted text skills. We will use a sweet romantic quote by Dory from the 2003 animated movie *Finding Nemo,* starring the cutest clown fish ever!

The bouncy letters from Jumping Sans look exactly like they are floating in water, and we'll just add a couple of flourishes to suggest underwater currents. And aren't our round letters just perfect as air bubbles? For a lettering artist, any letter can easily become an illustration!

STEP 1 — First use the horizontal guidelines on this page to practice the quote, without worrying about composition and just focusing on the letter shapes.

STEP 2 — As usual, use your pencil first to create the initial sketch of the composition on the next page. Writing on a slant can be tricky, but the guidelines provided will help you write the letters with the correct slant. Don't forget to keep the letters bouncing, too!

STEP 3 — When your pencil sketch is right, you can ink it. Once again, use bigger markers for the most important words.

STEP 4 — To put the icing on the cake, let's add a few flourishes to the composition! Keep in mind that the overall composition is based on sloped guidelines, so be sure to follow the same slant when adding swirls.

I look
at you
and I'm
home

Dory

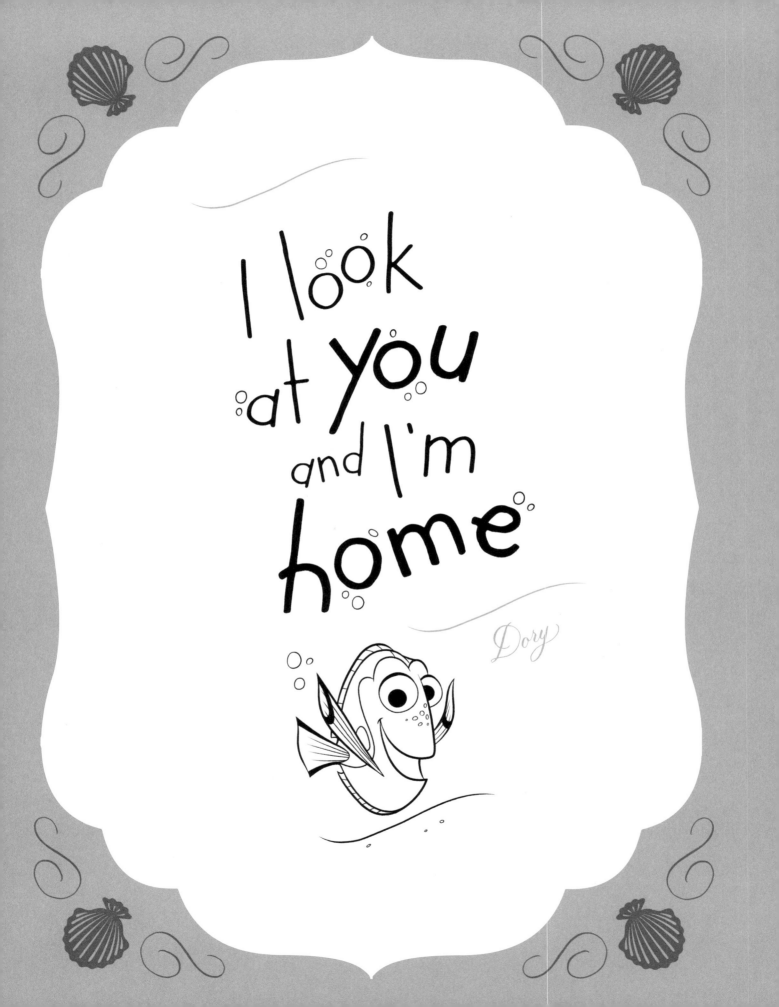

I look at you and I'm home

Dory

'OHANA
means family.
FAMILY
means no one gets left behind or forgotten.

Lilo & Stitch

They say
if you **dream**
a thing
more than once
it's sure
to **COME**
True

Aurora

straight
from
heaven
up above
here's a *baby*
for you
to *love*

Mr. Stork

SLEEP
WELL
Princess

Aladdin

Love

is putting someone else's **NEEDS** before yours

Olaf

It would appear that *together* or apart, we're still the best of *friends!*

Piglet

Hunny

calligrams

Hand lettering can be used to create beautiful pictures with words. The ancient Romans used to do this by creating poetry Calligrams called *carmina figurata*. Arabian calligraphers used written words to create amazing motifs depicting animals, plants, and objects. Our Calligrams start from a base of guidelines that flow around the shape of a Disney character. To write the quotes we will use the Modern Calligraphy style, loosely based on English Cursive (see page 18).

Difficulty: medium.

Tools and techniques: to create our Calligrams, you'll need a brush-pen marker that can create fluid strokes with a variable width. Make sure you have a selection of brush-pens of various sizes so you can create different textures and effects, as well as some fine-tip markers to write the smaller words and add fine details. This style is also perfect to practice with digitally, on any tablet that has a drawing stylus and good drawing software.

STEP 1 — Draw curved guidelines with a pencil to help you bend the words in different directions.

abcdef

STEP 2 — The basic letterforms are similar to those in English Cursive. Once again, you'll have to increase pressure to make the line thicker in downward strokes, while decreasing pressure to a minimum to get thin upward strokes.

make it flow

l r

STEP 3 — Connect letters in a fluid, sweeping motion, making the letters fill the space and creating a feeling of volume.

STEP 4 — Use flourishes to avoid empty space between letters and to emphasize important words.

STEP 5 — Always keep in mind the basic shapes you have learned from English Cursive; experiment fearlessly when writing your letters. Make connections longer and looser, and let the letters bounce on the baseline.

WHAT IS *Modern Calligraphy*?

Modern Calligraphy is a style of writing that uses English Cursive letter shapes, but has a more contemporary, expressive, and casual look. It is a more flexible way of writing that allows you to express yourself freely, loosen up, and free oneself from more formal script constraints.

There is a definite right and wrong way to create letterforms with traditional calligraphy. But with Modern Calligraphy there is only one rule: as long as the artwork is balanced and appealing to the eye, you've done a good job!

However, having more freedom doesn't mean there are no rules at all.

Just like in English Cursive, there are some basic ground rules that should be applied in order to maintain a visual harmony, like the alternation of thick and thin strokes in downstrokes and upstrokes. This is why it's recommended that you get traditional calligraphy under your belt first: it will give you an excellent foundation that will enable you to create your own personal calligraphy style!

With Modern Calligraphy, your imagination can run wild, because as we say at Disney, "If you can dream it, you can do it!"

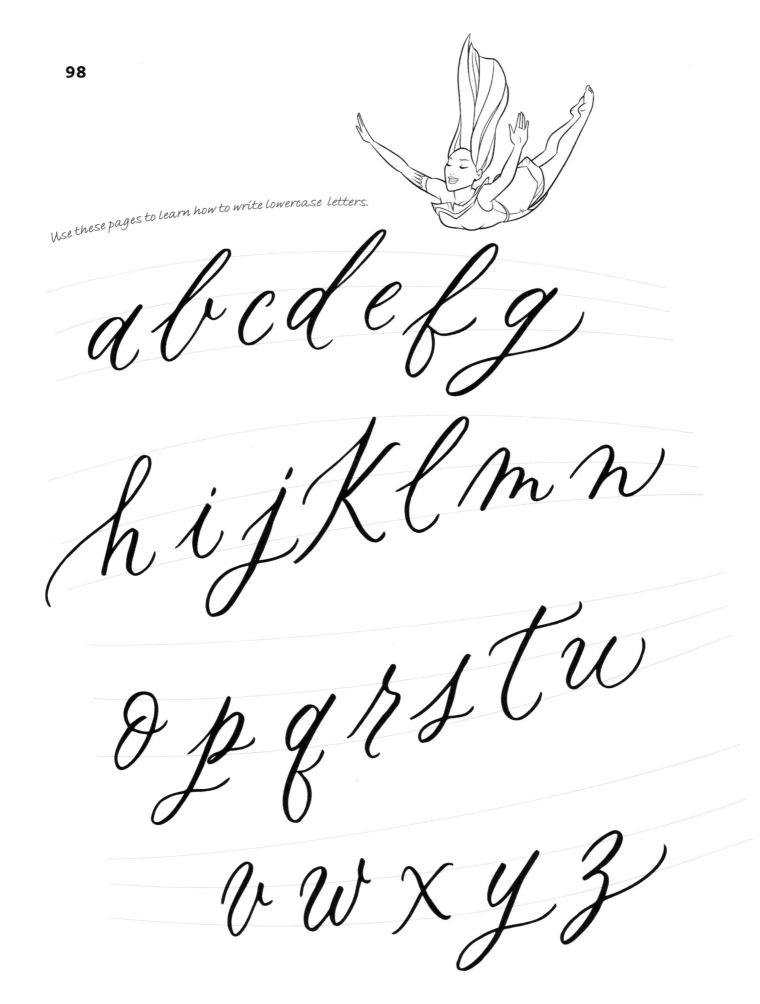

Use these pages to learn how to write lowercase letters.

a b c d e f g

h i j k l m n

o p q r s t u

v w x y z

fearless

flow

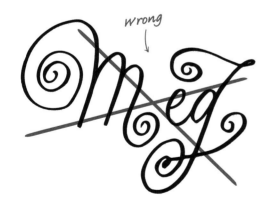

wrong

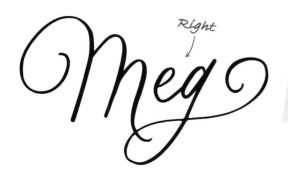

Right

GET YOUR SWASHES RIGHT!

When you try to do Modern Calligraphy, you'll be tempted to add swashes and swirls to every letterform. Be careful not to overdo it, transforming your artwork into a mess of lines!

The first thing to remember is that swashes are never spirals: each curve in one direction is followed by a gentle curve in the opposite one. Always use "S" and "8" shapes and add swashes and flourishes only to a few important letters—usually the initial uppercase letter or the final letter of the phrase.

Now let's practice capital letters!

A B C D E F G

H I J K L M N

O P Q R S T

U V W X Y Z

reverse inking

If you want to add special effects, remember that you can use opaque inks (white, gold, or any color you fancy) over a dark or black background. Lettering will come out in negative (white on black) and will be far more striking! This effect is extremely easy to attain with digital painting: you just have to work black on white and then invert the image at the end! With handmade calligraphy, you must instead use a white or gold ink in your pen nib, or an opaque acrylic marker.

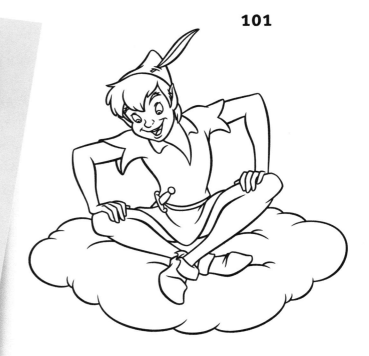

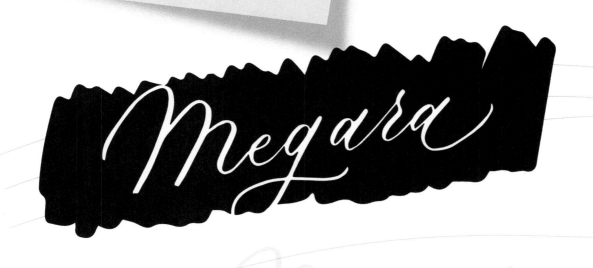

Megara

Megara

Belle

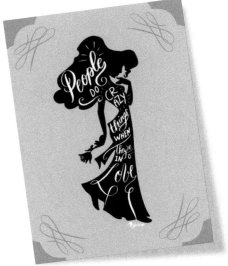

After practicing extensively with precise letterforms, it's time to go a little bit crazy and start experimenting!

And what better quote to start doing crazy things with than one by Megara, from Disney's 1997 animated feature film, *Hercules*? We'll use the words to build the slim figure of this reluctant minion of Hades with a cynical disposition and a passion for Hercules.

STEP 1 — Using a soft brush-pen, practice tracing the words on this page. We have provided various versions of each word, to let you experiment on different Modern Calligraphy variations of the traditional script shapes. Some require you to use thicker brush-pens, while others can be traced with a medium-sized marker.

STEP 2 — When you feel confident about the individual words, it's time to practice them in the composition. The guidelines provided on the next page follow the shape of the figure and allow you to fill Megara's silhouette in the most interesting way possible. We have suggested some word positioning using light ink, but feel free to experiment with different letter positions.

STEP 3 — You are now ready to create your final piece! Use the blank template on the right page of the following spread to create your first Calligram artwork, using the left page for reference.

People DO CRAZY things WHEN They're IN LOVE

Megara

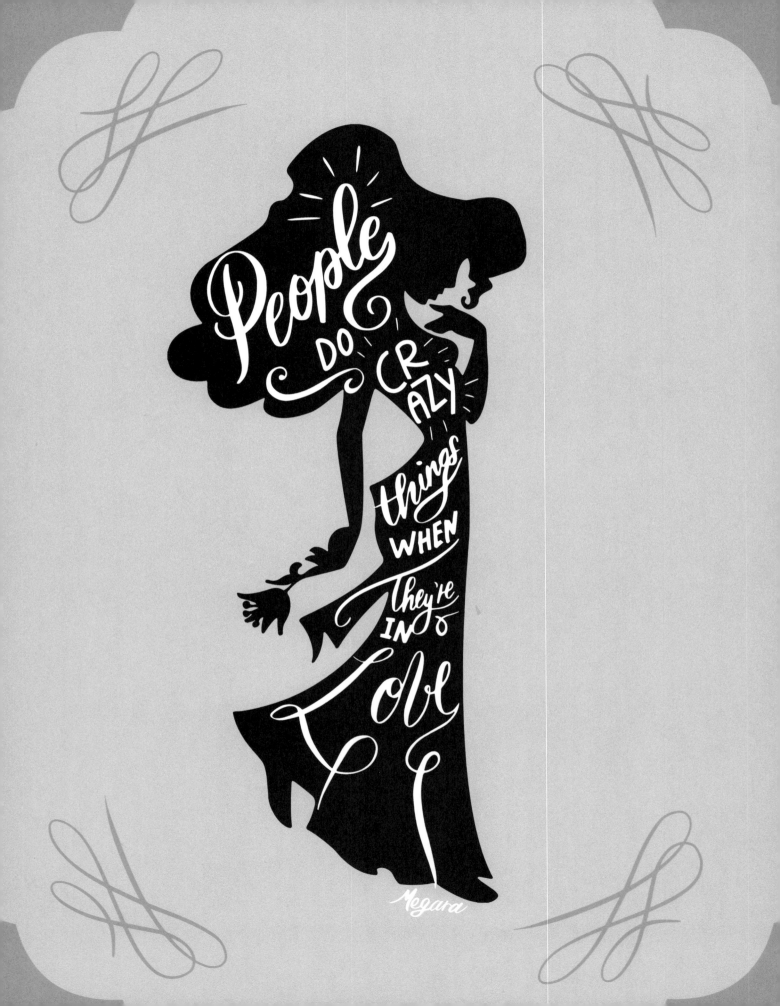

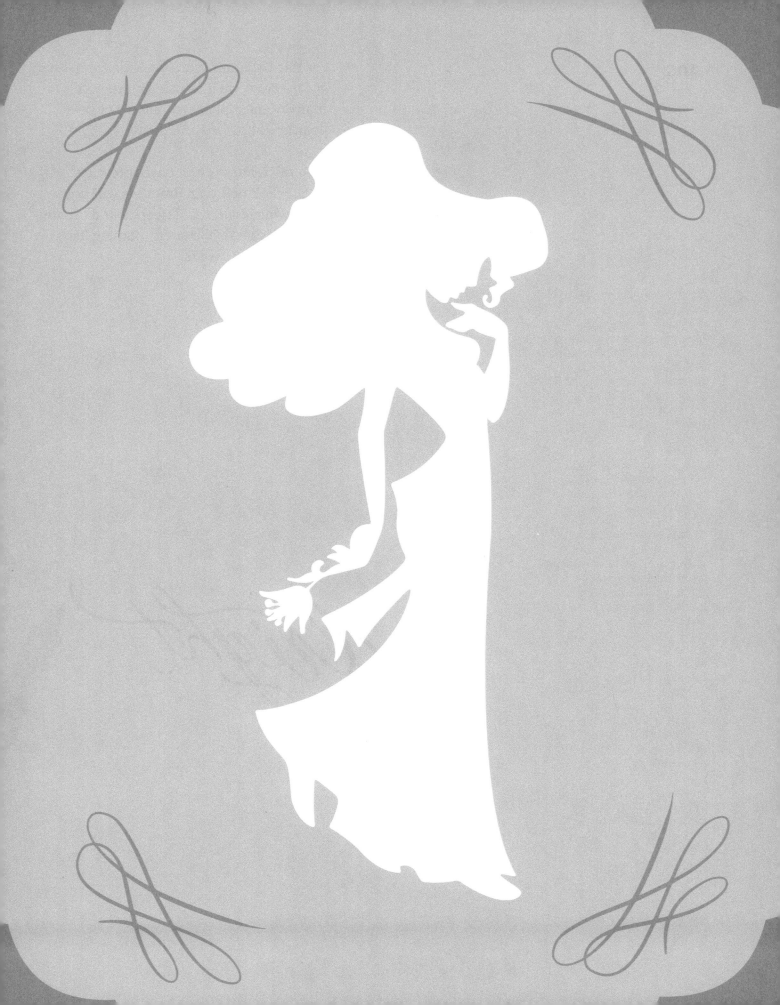

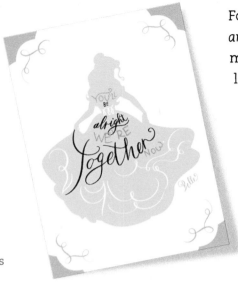

For this Calligram, starring Belle from *Beauty and the Beast*, we'll be using all the skills (and many of the alphabets) that we've been learning about up until now.

To re-create the flamboyant texture of Belle's ballroom dress, we will use flowing Modern Calligraphy and ornate flourishes, while using Jumping Sans for secondary words.

STEP 1 — Again, let's start by writing different versions of the same word, using brush-pens of various sizes, and practicing fluid lines that follow the guidelines we've set. In the examples on this page, we show you extreme variations in the line size: always keep in mind the basic rule of increasing pressure to make downward strokes thicker, while decreasing pressure to a minimum to get thin upward strokes.

STEP 2 — We are now ready to try to use our words to re-create Belle's shape. Once again, we have helped you with guidelines to guide you in the placement of the text. You can also use them to guide your flourishes. This is also the point at which you can try different inking techniques. For example, you could lightly trace the shape of letters with a pencil and then, rather than filling the lines, fill the whole silhouette with ink, leaving the words as cutouts in the black space.

STEP 3 — There's no need for extra instructions: turn the page, get a pencil, and begin your next masterpiece! The final piece of advice you need to create great art comes from Walt Disney himself: "Get a good idea and stay with it. Dog it, and work at it until it's done right."

YOU'LL

BE

alright.

WE'RE

Together

now.

Belle

YOU'LL BE alright WE'RE together now

Belle

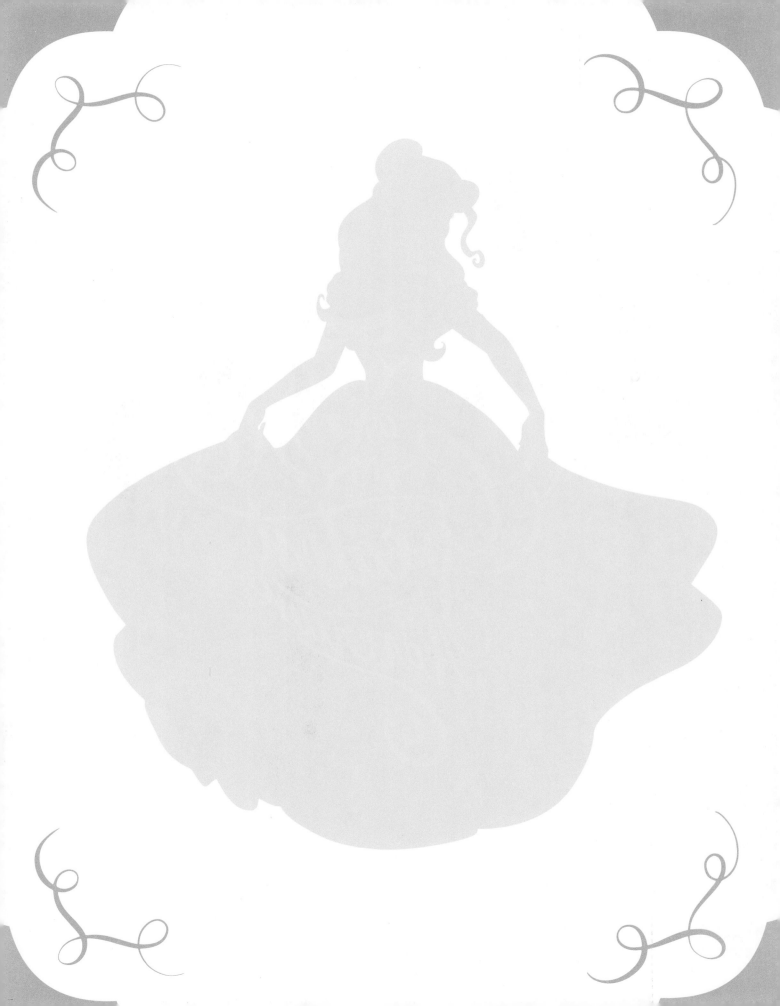

You are my Greatest Adventure

Mr. Incredible